Grace R. Simonetti 173 Charit Way Rochester, N.y.

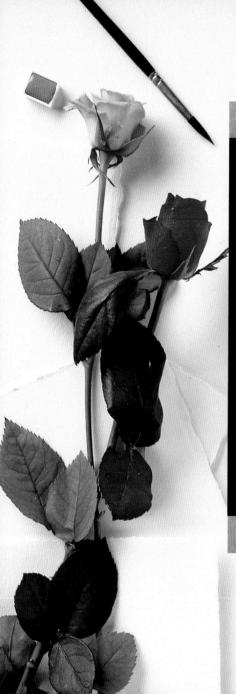

FLOWER PAINTER'S POCKET PALETTE

Instant visual reference on colors and shapes

Elisabeth Harden

CHARTWELL BOOKS, INC.

THE FLOWER COLORS

Yellow page 18

Published by Chartwell Books A Division of Book Sales, Inc. 114 Northfield Avenue, Edison, New Jersey 08837

This edition produced for sale in the U.S.A., its territories and dependencies only.

Copyright © 1996 Quarto Inc.

Reprinted 2000, 2001, 2002 2003

All rights reserved.
No part of this publication may be reproduced, stored in a retrieval system or transmitted in any form or by any means, electronic, mechanical, photocopying, recording or otherwise, without the permission of the copyright holder.

ISBN 0-7858-0578-8

This book was designed and produced by Quarto Inc. 6 Blundell Street London N7 9BH

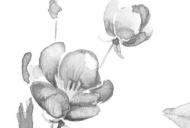

Orange page 24

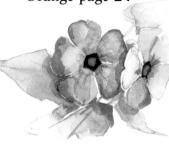

Pink page 34

Purple page 42

White and cream page 56

CONTENTS

HOW TO USE THIS BOOK 4

TECHNIQUES 6

FLOWER SHAPES 10

FEATURE PAINTINGS

USING YELLOWS AND ORANGES 18

Sunflowers

USING REDS 28

Oriental Poppies

USING PINKS 34

April Bouquet with Bowl

USING PURPLES 42

Daisies and Bachelor's Buttons

USING BLUES 48

Christmas Roses

USING WHITE AND CREAM 56

CREDITS 64

How To Use This Book

THE AIM OF this book is to offer a series of step-by-step flower portraits which explain the techniques involved, and analyze the particular color mixes required to create a spectrum of flower shades ranging from cool whites to richest purples.

The flowers are categorized into a series of basic shapes. An introduction describes each type, and the drawings examine the perspective and patterns of light and shadow that make up the three-dimensional form.

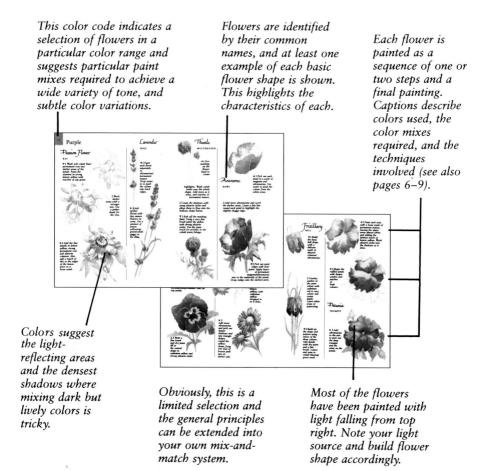

COLOR FOR FLOWER PAINTERS

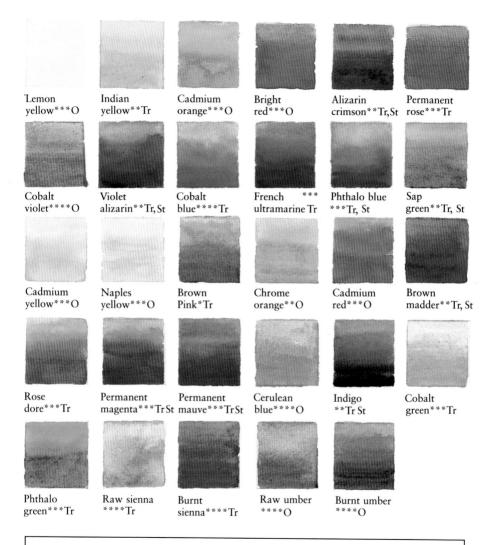

CODES

- **** Extremely permanent
- *** Durable color
- ** Moderately durable color
 - Fugitive color

- O Semi-opaque colors
- Tr Transparent or semitransparent colors
- St Particularly staining colors

TECHNIQUES

Watercolor paint can be manipulated in a number of exciting ways. Some techniques are extremely valuable for flower painters and produce textures and patterns unobtainable with a paintbrush.

Always remember the basic essentials for successful painting: an orderly work space, clean paints, and plenty of clear water.

WASHES

A wash is a flat area of color sometimes graduating to a darker shade. Mix enough paint for the whole area and apply it with a good-sized brush, mixing in a little water for the paler areas. Work subsequent layers quickly so as not to disturb the paint below.

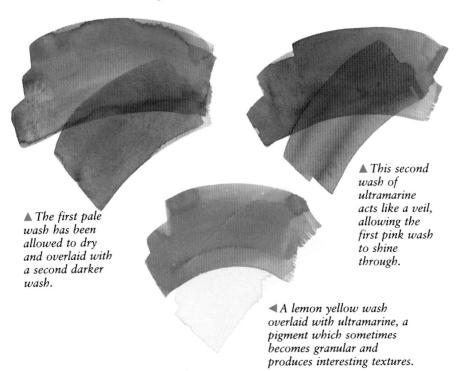

DRY BRUSH

Textures and petal marking can be made with a dry brush. Spread the bristles of a square-ended brush and use a little paint to create fine lines. A stiff brush can also be used for spattering and stippling paint - for stamens or speckling.

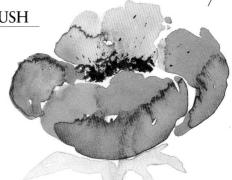

◀ A dry brush spread between finger and thumb and dabbed in dryish paint was used to make these fine lines.

▲ Dark speckles made by spattering paint off a brush with thumb or knife.

LIFTING OUT

A sponge, tissue, or cotton swab can lift damp paint, revealing soft highlights. To remove dry paint, work clean water into the paint with a firm brush. Dab out the loose pigment.

► These petal ¶ highlights were removed with a tissue. Thin lines of clean water were brushed into the paint and the color dabbed out to create stems.

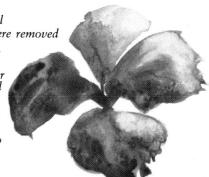

WET-ON-WET

Paint dropped onto damp paper will spread and create random patterns. More paint dropped into this will push the first paint back and dry into ruffled edges – just like petals. Feeding drier paint into a wash gives a subtle blending of color. Both methods are unpredictable and hence magical.

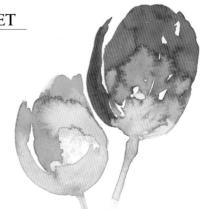

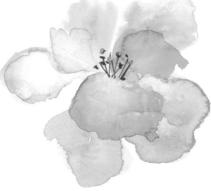

■ Back petals: drop paint onto wet paper. Hard-edged petals: drop water into drying paint. The front petals: paint in a loose wash of yellow and drop a darker yellow paint in as it dries. ▲ Strong paint placed next to an area of damp paint will fan into it. Such merges are invaluable for captuing the subtlety of plants.

CORRECTIONS

Contrary to beginners' fears, it is perfectly possible to make corrections in watercolor. Some staining pigments are difficult to remove, but others wash out easily and result in subtle surprises.

■ Odd dots of unwanted color can be removed with a sharp knife or scalpel. This is also a way of creating highlights.

MASKING

Masking fluid can be used to block out areas from a covering wash, either retaining white or protecting a color from a subsequent layer. Paint tends to pool around masked areas, giving a greater intensity of color and a sharp edge.

▲ Masking fluid masks the stamens and is rubbed off when the wash is dry. It ruins brushes so wash quickly.

■ Washing with a soft brush will gently remove paint.

■ More permanent pigments can be removed with a stiff, damp brush and tissue, though the weakened paper won't take additional paint successfully.

FLOWER SHAPES

BELLS

Bell-shaped flowers are generally seen with the light striking the upper dome and dark areas of shadow in the interior. Therefore pay particular attention to the way the stem joins the flower, its curve and color, and the character of the stamens inside the bell – sometimes just a tiny dot, sometimes a thrusting cluster of spikes. Petal edges will be seen as very light against the dark interior and should be sharply defined. Some might be smooth and curved, others ragged and uneven. The front edge should be sharper than the back edge.

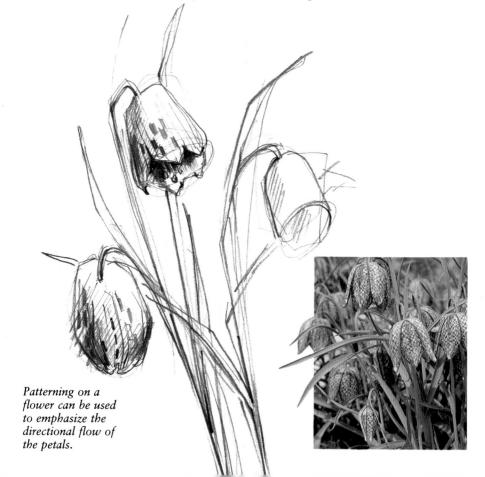

TRUMPETS

A simple trumpet resembles a cone – roughly elliptical at one end and narrowing to a point. The lower edges of the tube will be in shadow, and the inside of the trumpet darker still. Make sure that the spine or center of each petal curves into this point, as it will help to indicate the flower's splaying character. Use dark tones for the inside of the trumpet where it receives no light. The stamens will indicate the tubular nature of the flower, so use very dark tones for the shadowed areas between them, and notice also the shadows they cast. More complicated trumpets include the daffodil. The principles of a simple trumpet apply.

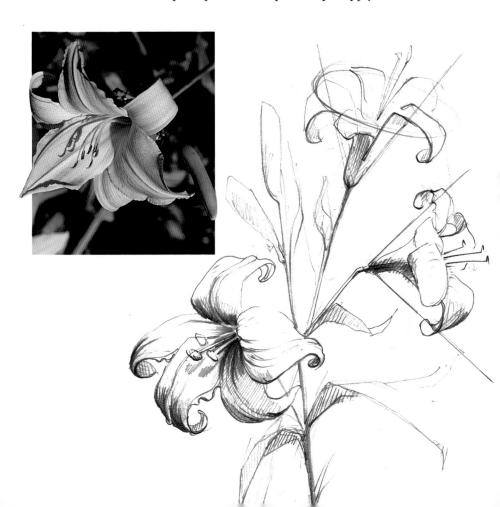

MULTIHEADED

Think of a multiheaded flower as a whole and then analyze the different components that make up this whole. In some cases, it will be a tight shape like a ball, with the underside of the flower head in deep shadow and upper parts partially dissolved by light. This same principle applies to multiheaded flowers of a looser nature. One of the secrets of painting a complicated multiheaded flower is to paint areas close to the eye in strong color and sharp detail, and to make distant blossom pale and hazy.

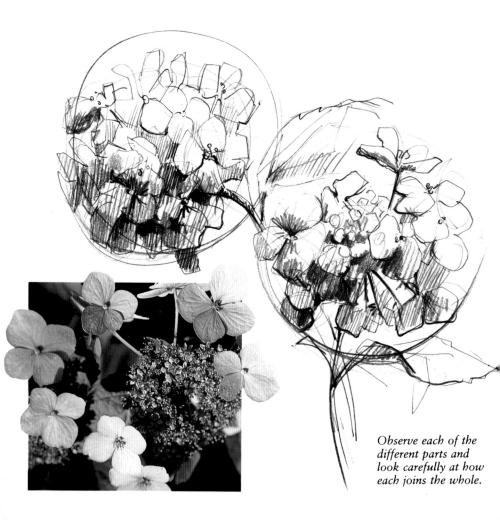

SPIKES

As with pompoms, treat this flower as a whole. Think of it as a cylinder. Analyze the general pattern of light and shade that make up the overall shape by looking through half-closed eyes at the silhouette and draw this shape. Then feature the particular: look closely at each floweret, its form, and the shadows it casts on surrounding flowerets and pick out some areas in detail. Some spikes consist of a series of flower blocks and leaves set at intervals on a stem. The line of this stem becomes very important. Follow this line through the whole shape.

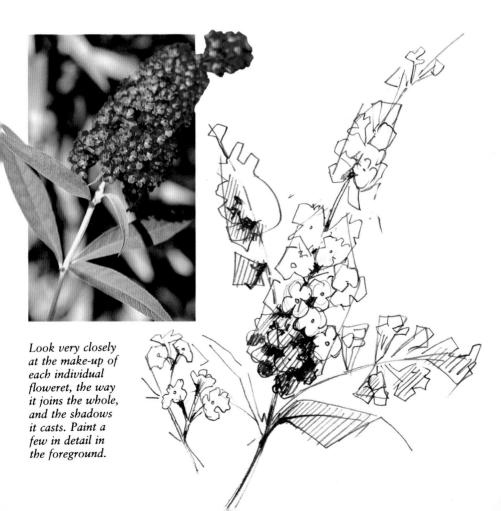

RAYS AND POMPOMS

Rays are always based on a circle – round when viewed head-on, but altered by perspective to a flattened disk as the flower turns away. The central dome acts in the same way. Take careful note of how and where the stem joins the flower and the features of that junction – bulky calyx or smooth seam.

Pompom shapes range from a domed circle to a globe. In each case, treat the flower as a whole rather than a cluster of individual petals. Having formed the basic shape, pick out a few petals to paint in detail.

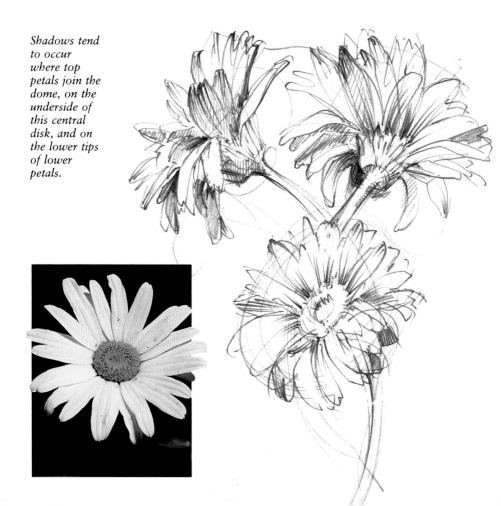

SIMPLE STARS

This is one of the easiest of types of flower to draw. Features to note are whether petals are each the same size, their texture, variation in tone and markings, and the character of the edges – ruffled, pointed, or upturned. The flower centers are clearly visible and can range from a series of minuscule dots to an exploding burst of stamens. This, together with the grouping of flowers on the stem, as single blossoms or as a cluster, gives these flowers their identity.

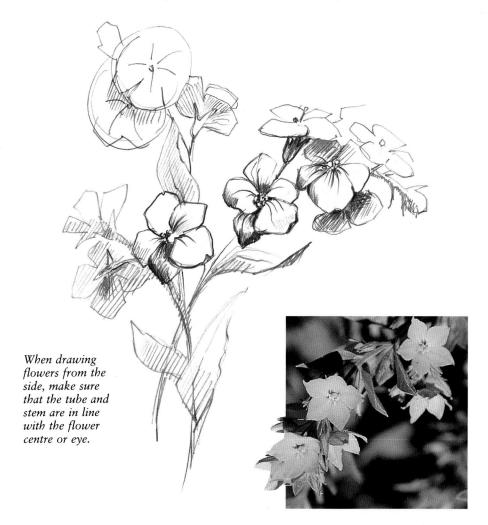

LIPPED AND BEARDED FLOWERS

This type bears close examination because even the most complex flower will reveal a simple underlying pattern. When cut in half, each side resembles the other exactly. When you have worked out the basic structure, then note the relative size of each petal, its texture, and markings. As petals bend away from the light source and where they overlap, there will be shadows, and the center of the flower may be very dark both in color and tone.

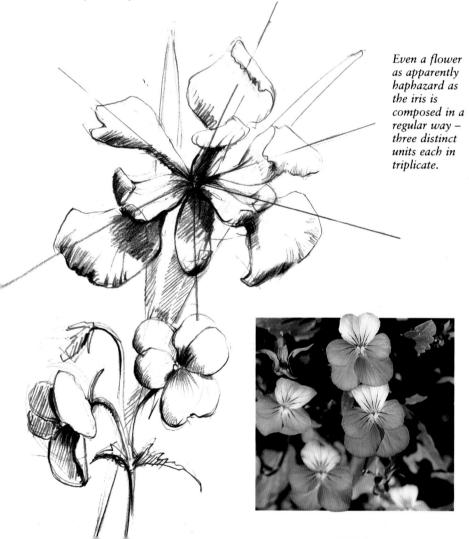

CUP AND BOWL

Think of these flowers, as the names suggest, as flat bowls or deep cups. The lip of the bowl or cup seen from above is a circle, but as it turns away from the eye it becomes an ellipse. Shadows are soft and delicately graduated on the upturned face of the flower, emphasizing the gentle curve of the petals, and dense and dark on the underside.

Look carefully at the way the flower head sits on the stem, the nature of this junction, and the positioning of the leaves in the stem.

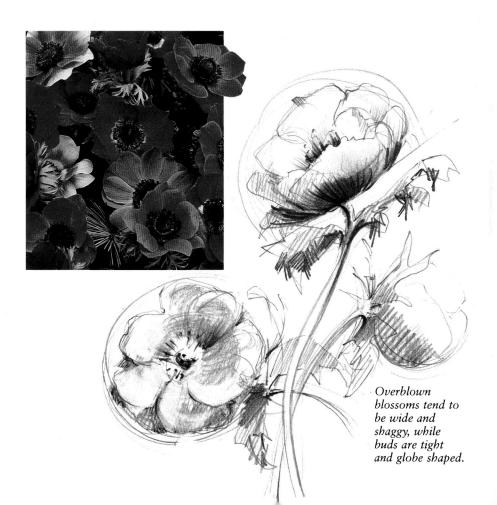

Yellow

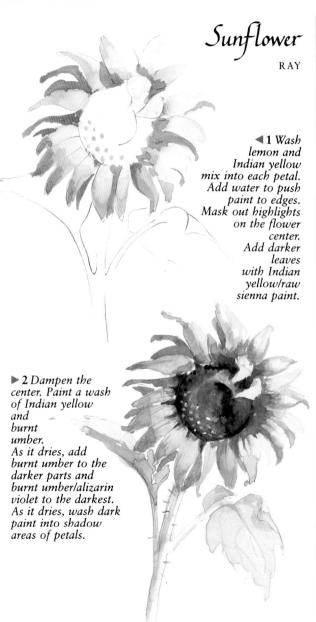

1 Paint lemon yelllow wash onto the petal, leaving some white highlights.

▲ 2 Build up the bell shape with cobalt green and raw umber touched into the drying paint.

Clematis

BELL

▲ 3 Paint details into the leaves with Naples yellow/raw umber mix and sap green/lemon yellow mix. ◀1 Paint the flowers in various mixes of Naples yellow/lemon yellow. Drop water in to lighten upper edges of flower.

Mullein

SPIKE

▲ 2 Pick out stamens in brown pink. Add Naples yellow/cobalt green for shadowed petals.

▶ 3 Fill in the main and side stems in cobalt green. Allow it to mix occasionally with the yellow.

SIMPLE STAR

◀1 Flood each petal with lemon yellow paint. As it dries, move it to petal tips and flower center.

► 2 Add stamens with cadmium yellow/brown pink, and sepals with lemon yellow/ cobalt blue mix.

Yellow

Sweet mimosa

MULTIHEADED

▶ 1 Paint puddles of lemon vellow in varying strengths to show near and far flowers. Drop water into some parts to push paint to edges. Paint skeleton of spray in pale green.

Tris LIPPED ■1 Drop cadmium yellow and Indian yellow into the petal. Drop water in to spread the paint.

2 Use Indian yellow with a touch of raw umber to add petal detail. Wash out highlights on front petal.

▶3 Paint details with raw sienna. Use sap green/raw umber mix on the stem.

Build
up
roundness
of the nearer
globes with
Indian yellow
and some raw
sienna/sap green.
Fill in leaves and
stems around flowers
in yellowy green.

Daffodil

TRUMPET

■1 Build up the petals with stripes of Indian yellow/Naples yellow mix. Leave white lines for petal ridges.

2 Wash Indian yellow into the trumpet shape. Push it full strength to edges. Wash patches of chrome orange into darker areas. Use a lemon yellow/sap green wash for leaves.

▶ 3 Pick out petal shadows with Indian vellow/raw umber mix. For dark areas of the trumpet add touches of strong raw and burnt sienna. Emphasise strap leaves in a darker sap green.

BOWL

◀1 Flood
Indian
yellow/
lemon
yellow into
light-facing
petals.
Remove
highlights
as it dries.

2 Indian yellow/brown pink for undersides of petals.

▶ 3 Add cobalt blue to the mix and sharpen shadow lines. Add stamens in lemon yellow, and leaves in sap green.

SUNFLOWERS

Betty Carr (28" × 21")

THE RICH VIOLET of the pitcher and subtle lilacs of the oriental vase enhance brilliant yellow flowers. The painter has used many shades of blues and purples, and yellows ranging from lemon to deep cadmium, and has used mixes of these dark and light colors to create subtle medium tones.

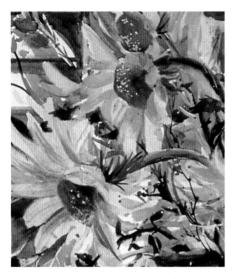

▼ The background flowers are indicated rather than painted in detail, petals with a stroke of a thick brush and a fine rigger brush used for the stem and frill of leaves.

▲ Shadowed parts of flowers need particular care – the darker tones are built up by adding red and burnt sienna. For the deepest areas, a touch of violet has been added to the yellow.

■ Reflection and deflection create their own patterns. These stems have become a jigsaw of greens, deep blue, and white, and stems are angled to lead the eye to the flowers above.

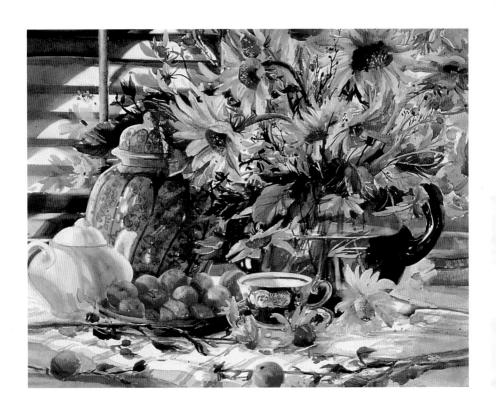

sap/phthalo

green.

Orange ▶ 1 Think of the flower as a ball. Draw an outline of the whole flower head. Fill in with a loose wash of Indian vellow deepening to cadmium orange. Chrysanthemum RAY ■2 Add brown madder to the mix. Dot into lower petals as they dry. ▶ 3 Lift petal shapes out of dark paint. Use the same color mix with burnt sienna for details. Paint leaves in various mixes of Indian yellow/

Wallflower

MULTIHEADED

▶ 1 Paint main petals full-strength Indian vellow. Allow it to create strong edges. As it dries, touch raw sienna into the shadows. Same for other petals. Use a fine brush to dampen areas and lift out highlights.

■1 Paint a variegated wash of Indian yellow onto main petals and a light wash of lemon yellow onto stem and leaves.
Leave some white areas.

◀1 Wash Indian yellow into front petals. As it dries, add cadmium orange.

Strelitzia

LIPPED

2 Wash a mix of cadmium red/Indian yellow over the petals, except for white and yellow areas. Feed more paint in as it dries. Mask out stamens.

Crown imperial

BELL

▶ 3 Mix brown madder into the mix. Paint the lower petals, varying tone and shade. Add darker sap green to stem and leaves. Remove masking and paint Indian vellow stamens.

■2 Fill in back petals, letting deeper cadmium orange flow into the bases. Paint the stamen ultramarine. Wash cadmium yellow/ cadmium red lightly into flower base.

▲ 3 Deepen the petal shadows. Dampen the flower base and flood in phthalo green.

Orange

Red Hot poker

■1 Paint a multitude
of petals radiating
from the center.
Use bright
red/cadmium
yellow mix for
the top petal and
cadmium yellow
for the lower petals.
Allow the
colors to mix
slightly and dot
cadmium yellow
into the orange.

▶ 2 When dry, use a fine, firm brush to lift paint from each floweret and raw sienna/bright red mix to emphasize dark areas.

2 Add more bright red and paint shadowed petals.

Day lily

TRUMPET

a darker
mix to
paint
petal
ridges.
Add
brown madder and
work into the center
of the trumpet creating
crisp white edges to the
front petals. Remove
masking fluid and paint
light Indian yellow stamens.

▶ 1 Paint each petal in Indian yellow/chrome orange mix. Wash out centers to create sharp edges.

► 2 Add the black centers with an indigo/burnt umber mix.

Black-eyed Susan

SIMPLE STAR

▼ 3 Paint fine lines radiating from centers in Indian yellow.
On the darker side, allow the center paint to blend in.

1 Paint a series of very pale washes in yellow and orange. Drop in water to create ragged edges.

▲ 2 Paint a deeper wash onto the lower petals with a touch of sap green at the base. Touch tiny areas of the petal edge with cadmium orange.

Iceland poppy

BOWL

▲3 Deepen the lower areas. Fill in flower center and stem with Indian yellow/sap green mix. Use very dilute paint for the shadow of the stem behind.

Red

Bottlebrush

SPIKE

◀1 Use masking fluid to block out the stamen ends. Only a few will show, but they will add sparkle to the strong red. Paint the stem in a mixture of lemon vellow and sap green, allowing the two to mix.

2 Use a fine rigger brush and dryish cadmium red to create a mass of fine stamens. Build up a second, closer layer with bright red.

▶ 3 Add depth to the areas of shadow by adding brown madder to the mix. Remove the masking fluid with an eraser.

wash of alizarin crimson on the light-facing petals of the flowers. Dab out light areas and build it up with cobalt blue and a mixture of ultramarine/ brown madder.

▲ 1 Paint a

Fritillary

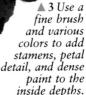

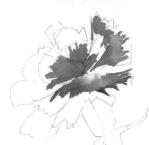

▲1 Paint a faint lemon yellow tinge on the upturned petals. Add a mix of permanent rose and bright red as a first wash. Allow the paint to pool on the lower edges.

Carnation

RAY

2 Add a mixture of alizarin crimson and bright red to the deeper petals. Tip the paper to allow the paint to settle around the spiky edges of the light petals.

Continue
adding darker
paint to areas
away from the
light, tipping the
paper to form
crinkly edges.
The deepest
colors are alizarin
crimson/bright red
and alizarin crimson
with a touch of
ultramarine.

Snapdragon

LIPPED

▶ 1 Dampen each petal in turn. Add a hint of cobalt blue to the lower edge. Add a mixture of alizarin crimson and cobalt blue just above, followed by alizarin crimson in the top half.

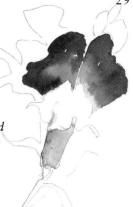

■2 Use a touch of ultramarine to paint shadow in the second petal. Paint cobalt blue on the light side of the flower body. Use alizarin crimson and cobalt blue on the shadow side, allowing the two to mix.

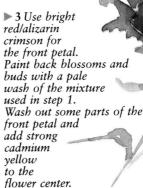

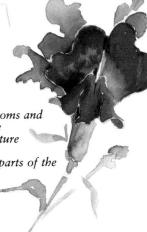

Red

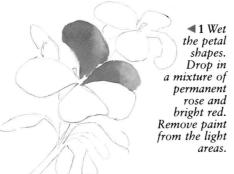

▶ 2 Paint a stronger mixture into the nearer petals. Use very diluted paint for the far blossom.

■3 Strengthen the shadows and petal veins with a fullstrength mixture. Add a touch of cobalt blue to the lower petal tips.

▶ 1 Dampen each petal in turn and drop in cadmium yellow and cadmium red. Let it pool toward the bottom of the flower. Add a touch of sap green as it dries.

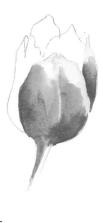

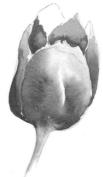

■2 Fill in further petals as before. Add a touch of alizarin crimson to the petal shadows.

Tulip

BOWL

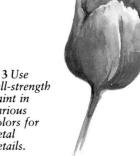

▶ 3 Use full-strength paint in various colors for petal details.

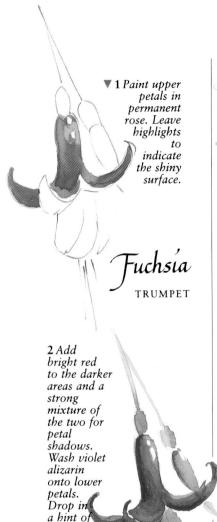

permanent

▶ 3 Reinforce

details with

appropriate colors.

flower

rose.

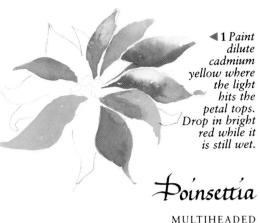

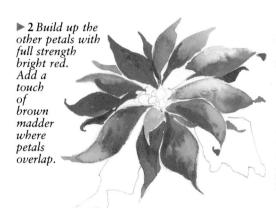

▼ 3 Wet each central brace and drop in cadmium yellow, bright red, and sap green. Paint deeper washes

ORIENTAL POPPIES

Shirley Trevena (21" × 28")

Poppies have the quality of crumpled silk, crisp and papery. Petal shadows tend to be a mass of tiny triangles and lozenges of tone, and petal edges are serrated and jagged. This painting captures the color and vibrancy of a mass of overblown blooms. Colors range from permanent rose, through bright red and deep madder to alizarin crimson and are painted wet in wet.

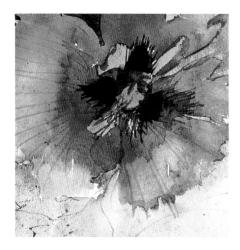

▼ The unpredictable patterns that result when wet paint is dropped into drying paint have been utilized here to create ruffled petals.

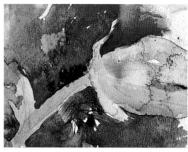

▲ The radiating petals of this full-face poppy are emphasized with lines scratched into the paper with a twig. Dark paint settles and soft washes of color are allowed to blend on top.

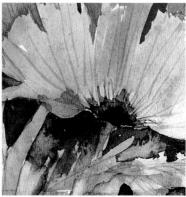

■ The distinctive shape of this poppy is created by the colored areas surrounding it, and its translucency enhanced by their intensity of tone. The focal point is the junction of stem to flower.

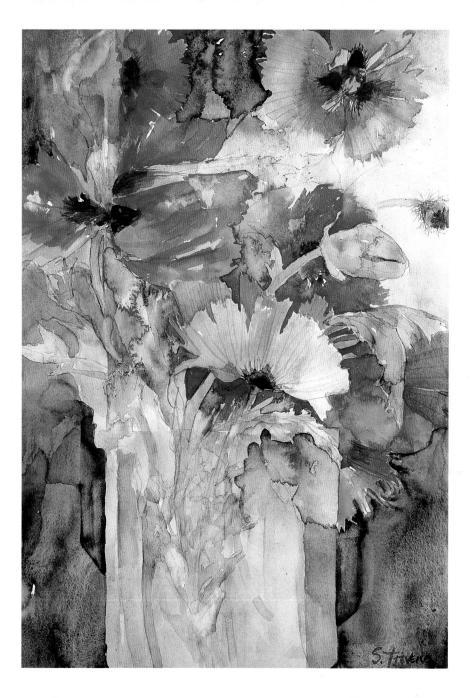

Pink

Foxglove

■1 Paint a light wash of permanent rose, leaving white highlights.
Add a second wash of magenta and a pale shadow of cobalt blue/permanent rose inside the flowers.

▶ 2 Add further washes to build up the shape. Pick out the inside bell pattern with a magenta/ sap green mix.

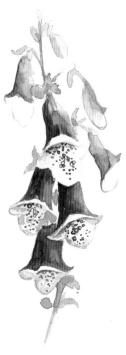

he the sun-facing petals with lemon yellow. Leaving some areas clear, wash permanent rosellemon yellow onto middle-tone petals. Tip the paper to let it flow into deep areas.

Rose

BOWL

2 Add cobalt blue for darker petals. Use ultramarine and alizarin crimson with the mix for the darkest petals.

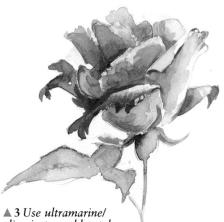

A 3 Use ultramarine/ alizarin to mold petals and dry paint for petal lines and points. Add a touch of cobalt blue to the bowl of the flower. Sap green/ cobalt blue for leaves.

▶1 Dampen each petal. Flood in a pale wash of permanent rose/lemon vellow. Push it to the edges of the petals. Dab out the centers.

Sweet pea

■ 2 Add further petals as before. Use a fine brush for details and petal ruffles. Paint leaves sap green.

▶ 1 Paint a pale wash of cadmium vellow onto back petals. Use a watery mix of lemon yellow and permanent rose on the front petal.

■2 Add more of the same mix as it dries, brushing the paint to make petal ruffles. Add a light wash of the mix to the back petals.

Oriental poppy

BOWI.

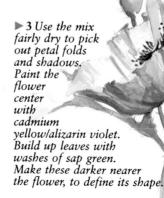

Pink

▶ 1 Paint a variegated wash of lemon yellow on sun-facing petals.

Gerbera

RAY

▶ 2 Use rose dore for a second wash. Allow it to settle in shadowed areas. ◀1 Mask stamens. Working each floweret separately, lay a pale wash of permanent rose.

Nerene

MULTIHEADED

▶ 2 Paint a darker wash on the nearer petals and add cobalt blue for shadow.

▲ 3 Build up a flower head from the separate flowerets, using paler colors for distant blooms. Remove masking. Add dark cadmium yellow flowerets. Sap green for stem.

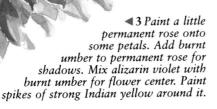

Pink

SIMPLE STAR

▶ 1 Paint a wash of rose dore/ cadmium yellow. Make it darker at the petal edges. Leave white highlights.

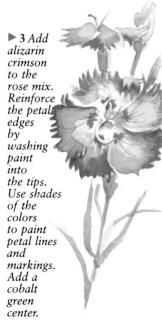

▶ 1 Paint a strong wash of permanent rose onto the front petal. Wash it out at the top edges.

Lily TRUMPET

■2 Mix a little ultramarine and paint the deeper petals.

▶3 Deepen shadow areas with the ultramarine/ permanent rose mix, and add yellow stamens and flower center.

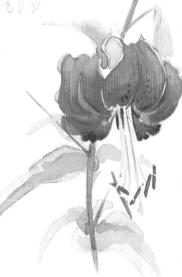

Pink

Working each red. Allow it to pool at the base of each petal. Touch some cadmium yellow in the centers.

Gladioli SPIKE

▲ 2 Using a stronger mixture, work the darker petals. Add some cobalt blue for the distant petals.

▶ 3 Use strong paint to paint petal ridges. Remove masking fluid and add sap green to the flower centers. Mix with phthalo green for leaves.

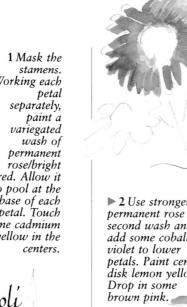

■ 1 Paint a variegated wash of permanent rose, dropping in some Naples yellow on the upper and sunfacing petals.

▶ 2 Use stronger permanent rose for a second wash and add some cobalt petals. Paint central disk lemon yellow.

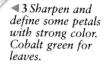

Cyclamen TRUMPET

▲ 1 Build up petals with light washes of permanent rose. Leave light areas white.

2 Add a touch of cobalt blue for darker parts. Lightly paint a wash of cobalt green on leaf.

▼ 3 Use sap green for dark pattern on leaf. Add rose dore for stem. Use strong rose dore for petal pattern.

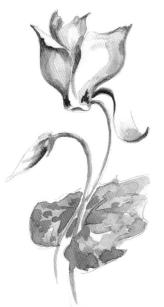

Rhododendron

MULTIHEADED

▶ 1 Paint a pale wash of cadmium yellow into the sun-facing petals. Put deeper color in the centers. Mask the stamens with masking fluid.

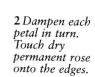

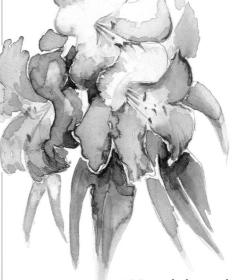

▲ 3 Paint darker petals in permanent rose. Add a trace of magenta for petal shadows and cobalt blue for the darkest areas. Use raw sienna/cadmium yellow for stamens, and sap green for leaves.

APRIL BOUQUET WITH BOWL

William C. Wright (28" × 21")

FABRIC AND FLOWERS successfully combine to create a rainbow of colors and a patchwork of pattern. Such busyness could become distressing to the eye, but here the artist uses a subtle web of line, stem, and leaf to draw the viewer into the focal point of the painting. Strong yellows, reds, pinks, and purples are arranged symmetrically, interspersed with white lilies and dark foliage.

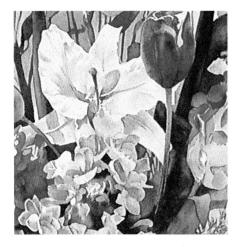

▼ Purple is a very dense color, which tends to recede. This tulip is painted in a whole range of shades from pink to indigo/violet.

▲ Cool blue gray describes the shadow and ruffled edges of the lily petals.
Trumpet-shaped flowers often have strong central spines on their petals which lead to the heart of the flower. Pools of shadow on the lilac emphasize its waxy character.

■ Flowers set on a light surface will catch some reflected light. The shaded petals of this tulip are a deep rich red, but touched with paler color at the base.

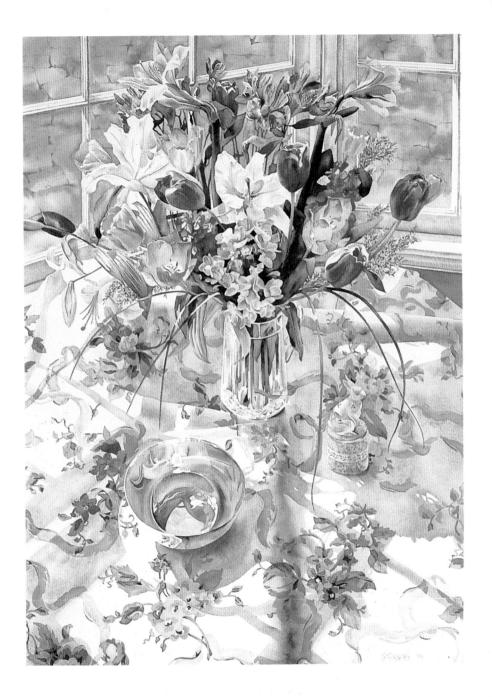

Purple

Lavender

SPIKE

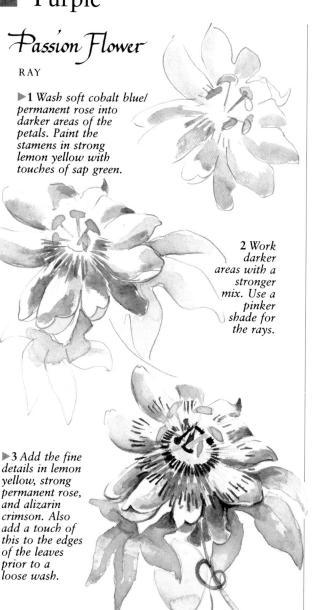

■ 1 Paint each floweret separately in ultramarine/ permanent mauve. Drop water in to push the color into hard edges.

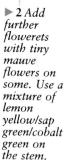

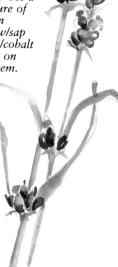

highlights. Wash cobalt violet over the whole shape. Add more as it dries, and touches of permanent mauve.

2 Create the shadows with stong alizarin violet and allow them to flow into the bulbous shape below.

▼ 3 Rub off the masking fluid. Using a very fine brush, paint the spikes with strong alizarin violet. Use the same brush for prickles in the cobalt green foliage.

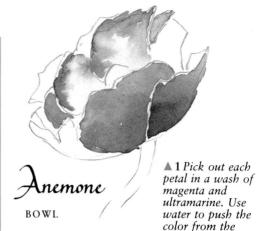

white areas.

2 Add more ultramarine and work the darker areas. Leave a fine line around each petal to highlight the slightly shaggy edge.

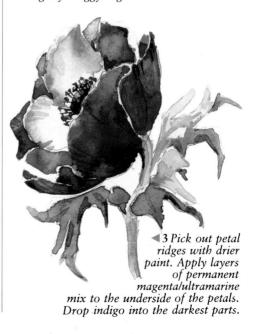

Purple

Pansy

LIPPED

▶ 1 Leaving a strace for the vellow apron, drop in fairly wet alizarin violet. Mix with a touch of ultramarine for the front petal.

2 Work stronger paint into the petals, and a mix of ultramarine/permanent rose for top petals.

SIMPLE STAR

▶ 1 Paint each petal with diluted cobalt violet/ultramarine Allow it to pool at the tip of each petal.

> ■2 Pick out the back petals and shadowed areas in a stronger mix. Paint the flower centers in lemon vellow, with cadmium vellow dropped in as it dries.

3 Add more ultramarine and pick out deeper shadows and tiny triangle shapes around the yellow dome. Drop wet dots of brown pink into its

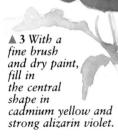

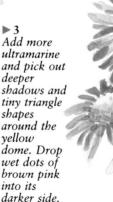

Fritillary

◀1 Build the basic bell shape with a delicate wash of alizarin crimson/ ultramarine.

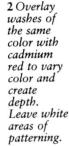

■3 Build up the shape and pattern using mixes of the three colors. Add details with dry paint and a fine brush. Leaves and stem in cobalt blue/sap green wash.

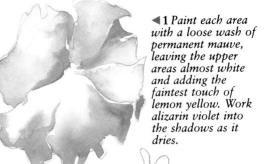

▶2 Shape the ruffled petals with deeper washes and patches of both colors.

TRUMPET

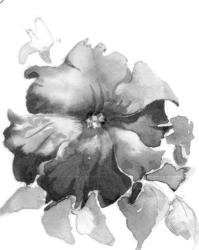

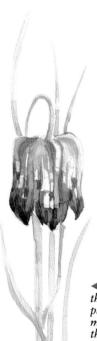

Daisies And Bachelor's Buttons

Elisabeth Harden (Watercolor 14" × 18")

This painting captures the ragged nature of bachelor's buttons and the fresh vitality of daisies. It is painted with a cool palette, basically ultramarine, cobalt, and indigo blues enlivened with touches of yellow for the daisy centers and a raw sienna wash for the background. The thrusting and winding stems have been suggested by painting layers of shadow around them. The distant flowers are painted with just a hint of shape and color, while foreground flowers have been emphasized with detail.

▶ Ultramarine has been used for these bachelor's buttons, full strength for the closer flower heads, and very diluted for the background. Masking fluid was initially used to protect the shapes of the stamens.

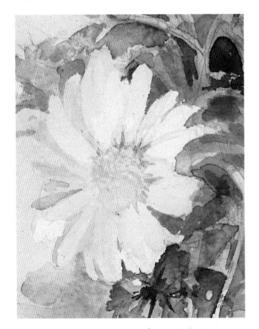

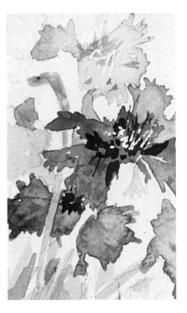

■ Painting a dark color around a white flower will create a solid form. The shape is built up by adding a flower center, shadow, and sharp triangles of detail. Treat petals as blocks of tone rather than individually.

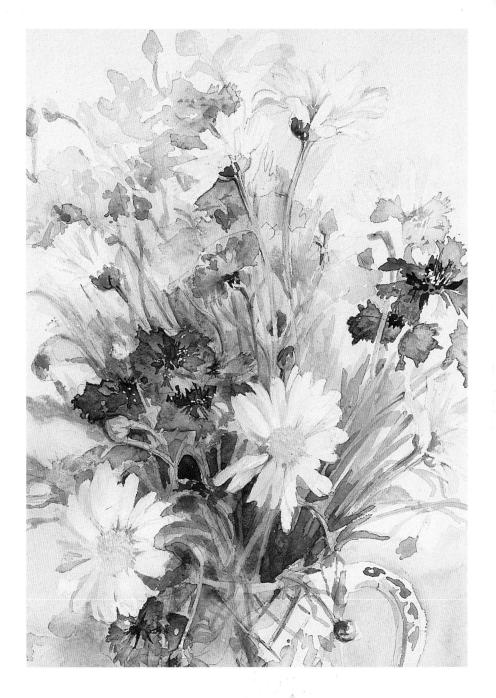

Blue

1 Mask stamens.
Flood the petal shapes
with ultramarine.
Remove it from
the upper
petals as it
dries.

Batchelor's buttons

RAY

▲ 2 Build up the center with cobalt violet, adding alizarin crimson stamens.

▶ 3 Remove masking fluid. Emphasize flowerets with stronger ultramarine. Use cobalt green/ lemon yellow mix for leaves. ▶ 1 Establish the middle-toned petals with a variegated wash of phthalo blue. As it dries, touch in specks of permanent rose.

Gentian

TRUMPET

▶ 3 Build up the trumpet with ridges of paint. Add crisp edges. Paint leaves with cadmium yellow/sap green.

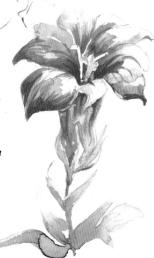

Delphinium

SPIKE

▼1 Dampen the flower shapes and drop in cobalt violet, ultramarine, ultramarine/ phthalo blue, and alizarin violet. Allow the colors to blend slightly and drop in more as they dry.

▶ 2 Use stronger paint and a fine brush

to build up the flower shapes, retaining the haze of blues.
Sap green for leaves.

Scabious

RAY

■1 Mask stamens. Paint a delicate wash of cobalt blue/ permanent rose. Drop in water to push paint to the petal edges.

■2 Add a darker wash to deeper-toned areas and shadow. Dot a pinker mix into the central dome and surround with cobalt green.

Remove masking.
Use various cadmium yellow/cobalt green/phthalo blue mixes for leaves and buds.

Blue

Blue Poppy

BOWI.

center

dots of lemon yellow

and brown pink. Add strong paint

to deepest areas and paint the stem

and bud in cobalt green.

with

2 Add more phthalo blue and paint into some of the darker areas, pulling the paint into petal ridges.

▲ 1 Paint a light wash of phthalo blue into each petal, leaving white highlights.

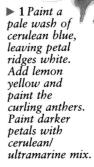

Love-in-the-mist

RAY

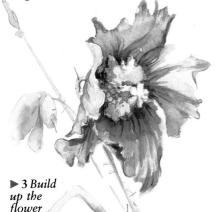

▲ 2 Mix ultramarine/ indigo for dark center, leaving white dots for stamens. Paint feathers and stem with cobalt blue/ lemon yellow mix.

Geranium

SIMPLE STAR

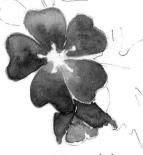

A 1 Paint a light wash of permanent rose/ultramarine. Add more paint as it dries to create an uneven effect. Paint a second wash of ultramarine and build up the lower flower with petal shapes of watery paint.

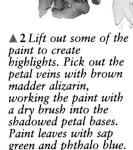

▶ 1 Dampen each petal. Paint an ultramarine wash, leaving the flower center white. Add a little alizarin violet to the upper petals.

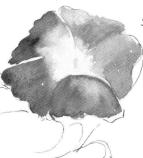

Morning glory

▲ 2 Paint a second wash of stronger ultramarine/alizarin violet. Darken the paint toward the edges. Mask the stigma. Paint flower center Indian yellow.

stronger
paint to
indicate
petal flow
and uneven edges. Paint
two washes of sap green
for leaves. Add alizarin
violet for winding stems.

Blue

▶ 1 Use cerulean blue for lighter, distant flowers, and cobalt blue for closer. brighter flowers, drop dots of paint to create flower heads. Allow some of the dots to blend and add touches of permanent rose.

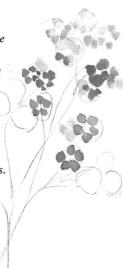

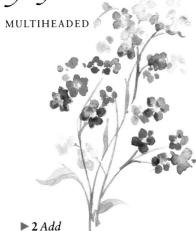

detail to
some close
flowers. Use
cadmium yellow
for a few flower centers.
Link all flowers with threads
of stems of sap green.

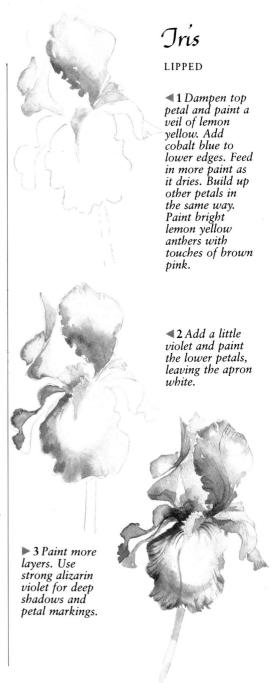

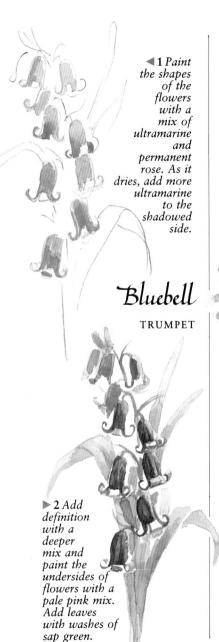

▶ 1 Paint a loose wash using ultramarine/ rose madder for the upper petals and phthalo blue for the shadowed parts. Drop in lemon yellow as it dries.

■2 Paint a second wash, giving definition to deep-set areas and particular petals.

▶ 3 Using the same colors, build up a mass of flowerets. Mix lemon yellow and phthalo blue for the leaves.

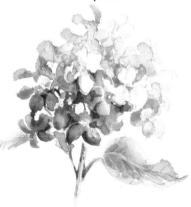

CHRISTMAS ROSES

Elisabeth Harden (5½" × 5½")

FLOWERS PAINTED CLOSE up develop a different dimension, areas of shadow become a landscape in themselves, and subtle gradations of color create hills and valleys. A limited palette has been used – phthalo green, cobalt green, indigo, cadmium yellow, and brown pink, giving the painting a monochromatic feel. The artist pushed the paint into hard edges with a brush and hairdryer to create the ruffled petals.

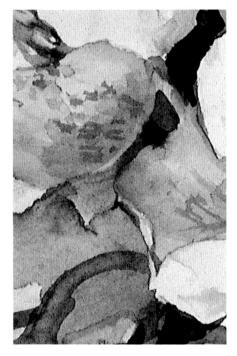

▲ The dark phthalo green/indigo mix used for the background was gently brushed onto each petal, making sure that the area under the overlapping petal edge was darkest.

▼ The anthers were masked and painted in a mixture of colors. They are a focal point of the picture.

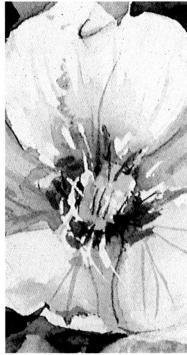

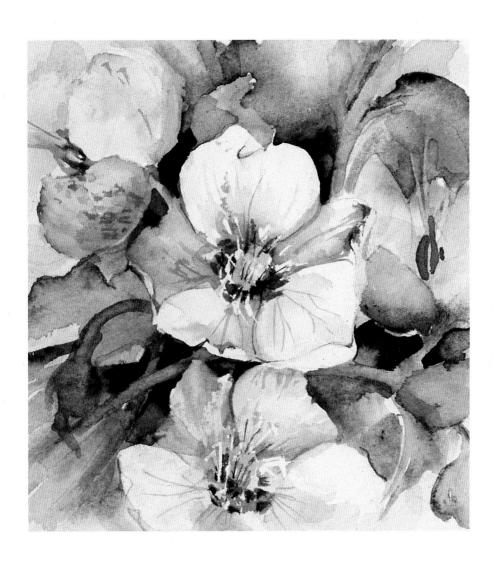

White and cream

Lily

■1 Outline
the flower
with Naples
yellow/cobalt blue mith
cobalt blue.

2 Use permanent rose for ridges on trumpet and underside of petals. Add touches of rose and cobalt for petal ridges and frills. Use strong lemon yellow for flower center.

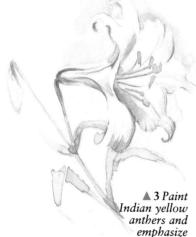

stamens with Indian

yellow/cobalt blue mix.

Snowdrop

BELL

▶ 1 Use ultramarine wash to define each flower shape. Push color toward edges to sharpen some outlines.

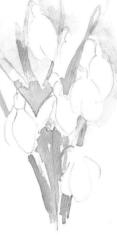

▶ 3 Paint flower stems and sepals in cobalt blue/lemon yellow. Add ultramarine/lemon yellow to clarify leaf shapes. For petals use a touch of indigo.

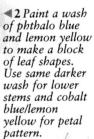

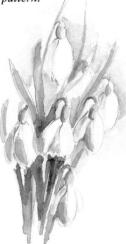

Apple blossom

SIMPLE STAR

▲ 1 Use a loose wash of cadmium vellow/sap green for the blossom outlines. Paint patches of diluted permanent rose for middle-tone petal areas, leaving large areas of white.

2 Paint a darker wash on the leaves. Blend some of the green paint into the pink for shadows.

Water lily

BOWL

▶ 1 For the shadow of upper petals, use cobalt blue, adding a trace of brown pink. Use a deeper mixture for the lower petals.

> ■ 2 Paint deeper shadows in cobalt blue. Stamens in lemon and Indian yellow. Indian yellow/sap green wash on leaves.

▼ 3 Use stronger mixes of flower and leaf colors to build up depth and color, and fine brushwork for stamens and deepest crevices.

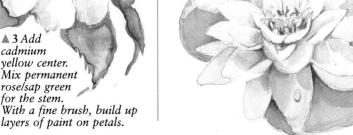

▲ 3 Add cadmium yellow center. Mix permanent roselsap green for the stem.

White and cream

▶ 1 Paint a variegated wash of ultramarine around the flower.

Daisy

RAY

2 For shadows on petals, use cobalt blue, dropping in some Indian yellow. For back petals and deep shadows, use ultramarine with traces of alizarin crimson, use lemon for the dome.

■3 Moisten the dome. Build the shadowed side with drops of Indian yellow and brown pink. Pick out crevices with ultramarine. ▲ 1 Outline the white petals with a pale cobalt blue/lemon yellow mix. Use strong lemon yellow for each flower center.

Cape Frimrose

TRUMPET

2 To build up the trumpet shapes, gradually add touches of cobalt blue

> ▲ 3 Add phthalo blue for the darkest shadows and hints of definition on petals.

■1 Paint a light lemon yellow wash on the petals, leaving plenty of white. Use strong Indian yellow for flower centers.

rangipani TRUMPET

Establish flower shape with

a wash of lemon yellow/sap green. Use pale cobalt blue for shadows and alizarin violet for deeper shadows.

■3 Work into leaves with darker sap green. Sharpen flower center and underside of stems with brown pink emphasizing swirling character of blooms.

Rose

BOWL

1 Paint a wash of Naples/ lemon vellow onto the petals. Leave white highlights.

▲ 2 Surround the flower with a wash of sap green/rose dore. Paint darker areas of petals with Naples/lemon yellows.

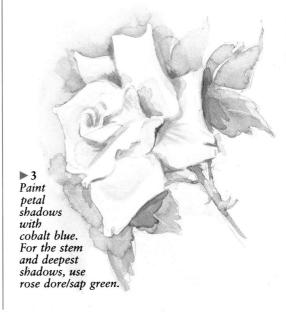

Green

1 Paint a pale wash of lemon yellow on each petal. Then a second wash of lemon/ cobalt blue. Use tissue to dab out highlights.

▶ 2 Moisten the apron and paint the ruffle in alizarin crimson so that color pools at edges. Add fine crimson lines on petals.

Orchid

▶ 3 Use appropriate colors to build up tone and fine details.

1 Establish the flower outline with a cadmium vellow/ sap green wash. pushing it toward the edges. Paint the inside of the trumpet with cobalt blue/sap green mix. Tip the paper so that the paint pools in deepest shadow areas.

▲ 2 Add touches of indigo for underside

of petals.

in strong

Paint stamen

cadmium yellow.

▶ 1 Make tiny stars with masking fluid for lightest flowerets. Paint a wash of lemon vellow.

Lady's mantle

2 Add masking fluid. For the second wash, add cobalt blue.

■3 Add more cobalt and paint the top leaves. Add a little phthalo blue and paint darker leaves and shadows. Leave fine lines to pick out serrated edges.

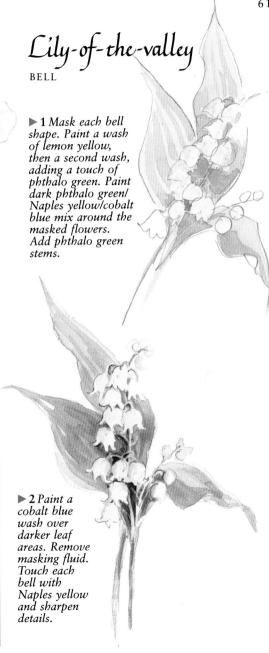

Leaves

Форру

■1 Paint a wash of lemon yellow.

▼1 Paint a light wash of lemon yellow. As it dries, add a lemon yellow/cobalt green mix.

Tvy

▲ 2 Use sap green for a second wash, omitting the leaf ribs.

▼ 3 Add phthalo blue and a touch of ultramarine to the mix. Paint darker patches, blending the paint with a dry brush.

▲ 2 Build up the leaves with patches of cobalt green. Add cobalt blue for darker touches. Emphasize petal edges with a fine brush.

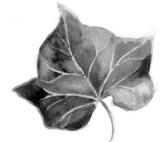

▲ 1 Paint a wash of cadmium yellow/cobalt blue. Touch in a scalloped edge with cadmium red.

Geranium

▶ 2 Add phthalo blue to the mix and paint a variegated wash.

▼3 Add cadmium red and stipple in patterning with a stiff brush.

1 Paint a wash of lemon yellow. Dab out highlights with tissue.

▲ 2 Mix sap green and lemon yellow. Paint a second wash, omitting leaf spines.

Myrtle

▲ 3 Add some phthalo blue and paint in deeper areas of leaves. Remove paint from lighter areas where necessary.

CREDITS